DEGAS' BALLET DANCERS

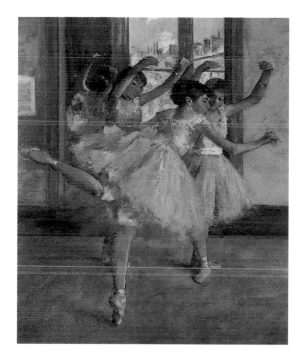

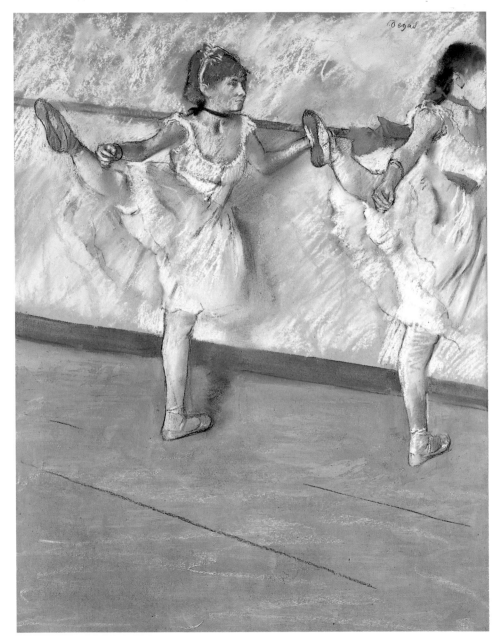

DANCERS AT THE BAR, 1877-79

DEGAS'
BALLET DANCERS

Universe

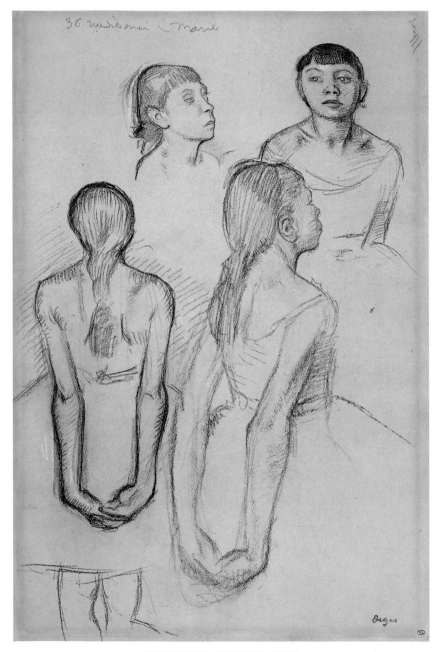

FOUR STUDIES OF DANCERS, C. 1879

INTRODUCTION

The world of the ballet provided Degas with the perfect background for his art. In its rehearsal rooms, performances and audiences he could observe with a brilliant eye the development of modern life. For Hilaire Germaine Edgar Degas (1834-1917), like many of his contemporaries, the will to paint was fuelled by his experience of the world around him, specifically nineteenth-century Paris, rather than by an idealized vision of the past. The poet Baudelaire's cry to the artist to concentrate on 'the passing moment and all the suggestions of eternity that it contains' epitomizes the cultural background in which Degas painted his celebrated ballet scenes.

In his book, *Degas: An Intimate Portrait,* the picture dealer Ambroise Vollard quoted the artist as saying: "People call me the painter of dancing girls. It has never occurred to them that my chief interest in dancers lies in rendering movement and pretty clothes." Although Degas often made comments like this which undermine the complexity of his ballet paintings, it is undeniable that he intended more than purely a celebration of pretty girls in motion. The scenes of the ballet are so effective because of their dual nature: traditional, academic technique is used within daring new compositions, and universal emotions are expressed through contemporary individuals.

By the middle of the century the ballet's standing had dwindled and it was no longer recognized as a high-status cultural event. Standards of choreography and performance had declined and it now provided little more than an interlude between opera scenes. It is thus remarkable that Degas' paintings were so popular and highly marketable. Having started his artistic career by making copies of the works of the masters of the Renaissance and the French Academy, Degas came to the ballet almost by accident. He was undoubtedly aware of the precedents for such scenes: the printmaker Honoré

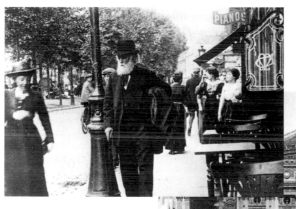

THE PARIS OPÉRA AT THE TURN OF THE CENTURY AND DEGAS PHOTOGRAPHED IN PARIS, C. 1914

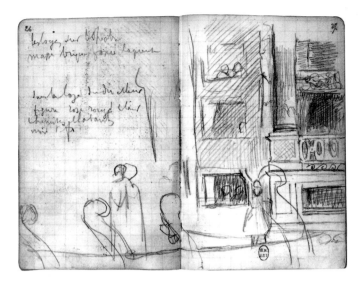

frequented the ballet, Halévy's tales offered both entertainment and social comment. Degas was to produce a series of mono-type prints illustrating scenes from the story over the next two

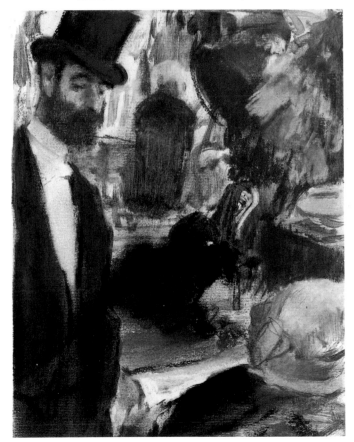

Daumier (1808-79) had used the Opéra as a setting for many of his incisive social observations and Edouard Manet (1832-1883) had made portraits of some of the visiting performers, but Degas' approach was quite original.

The Opéra itself was a focal point of nineteenth-century Parisian society. Rebuilt in 1861-75 by Charles Garnier with funding from the government, it stood at the meeting point of several boulevards, and quite literally commanded the eye in that area of the city. But it was not only a visual focus: Degas and his contemporaries were fully aware of the Opéra's role as an arena for political and social intrigue.

In 1872 Degas' close friend, the novelist and librettist Ludovic Halévy, wrote *La Famille Cardinale*, a satirical observation of life backstage at the Opéra. Focusing on the phenomenon of dancers' mothers who were believed to promote sexual relations between their daughters and the wealthy men who

decades. His close relationship with Halévy partly explains his involvement with the ballet, for both men were part of the social circle which inhabited a place of privilege within Parisian society. Born into a family of bankers connected to the Italian nobility, Degas had been brought up on a cultural diet which involved regular attendance at the Opéra during his youth, and it was a natural place for him to socialize as an adult. The men of his generation made up the group which came to be known as the *balletomânes*, who attended performances every night, sharing between them subscriptions to the best *loges* or boxes in the theatre. It is from a viewpoint afforded by one of these boxes that many of Degas' performing ballerinas are seen. Similarly, many of the rehearsal scenes place the on-looker either in the wings or seated on the side of the stage. These views inherently imply the privilege of the wealthy, powerful men whose support for the young ballerinas was widely accepted to be more than financial and Degas obviously had no qualms about portraying this relationship, regularly placing comical, black-suited figures in his compositions.

But for Degas the ballet paintings were more than just a reflection of his social standing, for they celebrate the meeting of the magic of the performance with the harsh reality of the lives of the dancers. As if transformed by the glare of the footlights, Degas' dancers transcend the hours of exhausting exercise and years of examinations to become exquisite ballerinas. It was this dedication to their profession which impressed and interested Degas, for to work endlessly and repetitiously to achieve a beautiful effect in art was a belief which he held dear. In an enlightening account of the artist's relationship with one of his models, he is reported to have said: "And when people talk of ballet dancers they imagine them as being covered with jewellery and lavishly maintained with a mansion, carriage and servants, just as it says in story books. In reality most of them are poor girls doing a demanding job and who find it very difficult to make ends

DEGAS' PARALLEL THEME OF FEMALE BATHERS
EXEMPLIFIED BY *THE TUB*, 1886

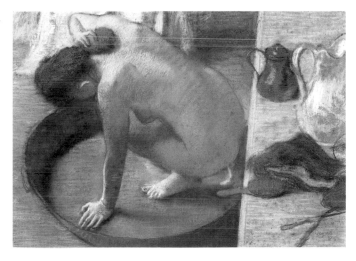

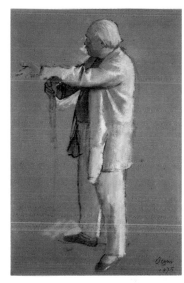

THE BALLET MASTER,
JULES PERROT, 1875

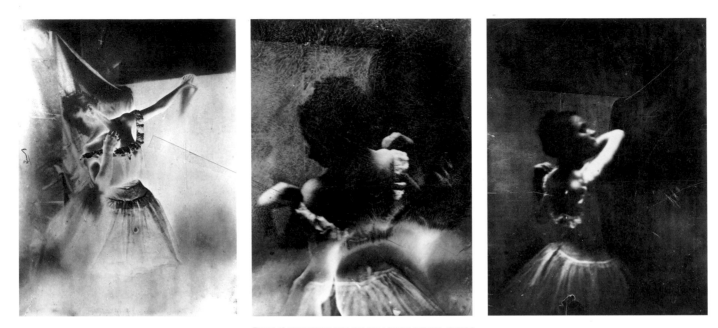

DEGAS' PHOTOGRAPHS OF BALLET DANCERS, C. 1896

meet." As the dancers practiced their steps and positions in rehearsal rooms, accompanied by violinists and commanded over by ballet-masters, Degas drew countless sketches of them, his repetition of a particular pose in the struggle for perfection mirroring their efforts. This respect for a social class of real, independent, working women was not limited to the ballet. His paintings of laundresses, bathers and prostitutes testify to his interest in depicting the lives of citizens which may have otherwise have gone unremarked.

In a sense the young dancers in his paintings could represent any one of the working-class girls who came to the Opéra school as young as seven or eight and worked their way through the regular dance examinations so often represented by Degas. Their individuality is suppressed by the generalized physiognomy and stock poses of the figures, despite which art historians have dutifully sought to identify certain dancers. Occasionally Degas does portray figures who we can recognize as celebrities of the Opéra, although their names are never noted in the title; even the *Orchestre de l'Opéra*, Degas' first major ballet composition does not identify the numerous portraits it contains. The ballet instructor Jules Perrot is one such person who features in many of the paintings. The distinctive

features of the retired star of the Opéra can be seen in various guises – for example as the pivotal figure of the Musée d'Orsay's *Dancing Class* of 1873-76 and the tiny background presence in the Burrell Collection's *The Rehearsal* of 1874. In a world of imagery where places and people remain unspecific, Degas must have had a reason for making identification of Perrot so easy. It is thought that to the artist 'Perrot the aeriel, Perrot the sylph' (as the poet Théophile Gautier described him) represented the romantic past, both of the ballet and French history. He belonged to the generation of Degas' father who had instilled in his son a love for music and dance. On a more practical level, it is to be remembered that despite the large number of pictures that Degas produced of the ballet, he actually drew from life there only a few times, re-using studies and sketches in various combinations. Like many of the dancers who can be seen in numerous paintings in almost identical positions, the figure of Perrot gave the artist a standard for the ballet-master, reversing the pose and altering the scale, in the same way that Michelangelo manipulated many of his figures on the ceiling of the Sistine chapel.

His visual sources for the figure of Perrot were a study in *essence,* paint diluted with turpentine, and a daguerreotype photograph taken in 1860 by Bergamasco which shows the teacher in the exact pose and similar dress in which he appears in Degas' paintings. For Degas, like so many of his contemporaries, the development of photography from a laborious and somewhat experimental process to a simpler and more refined technique towards the end of the century was both exciting and useful. Despite being one of the more traditional artists in the Impressionist circle, Degas was happy to embrace the camera as an aid for his art, using it to photograph models to eliminate hours of unnecessary posing, and incorporating some of its visual effects into his pictures. The dramatic cropping of many of his compositions and the 'snapshot' capturing of an unexpected gesture or movement owe a great deal to his passion for photography, which became an increasing preoccupation in his old age.

In their attempts to represent the changing world around them – the rapid growth of the city, the physical changes in its architecture and the escape from it made possible by the railways – the Impressionists searched for new ways of seeing. The innovations facilitated by the camera were also made enhanced by the artists' exposure to a new kind of art. Trade agreements between France and the East meant that after centuries of isolation Japanese

JAPANESE PRINTS WERE A MAJOR INFLUENCE ON DEGAS' WORK

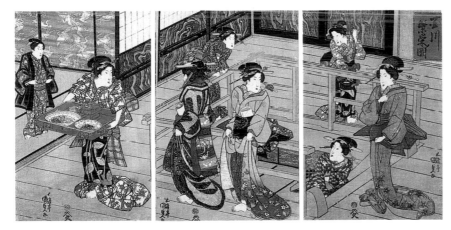

culture came flooding into Paris, at once shocking and delighting its artistic circles. Some artists actually incorporated certain motifs into their work or used techniques such as woodblock printing, but for Degas it was the asymmetrical compositions and dramatic perspectives of the prints that influenced the way in which he painted, as can be clearly seen in so many of the ballet pictures.

If we can see similarities and a particular way of working running through the paintings of the dancers, it is also true to say that despite working consistently on the theme for more than thirty years, Degas never ceased to discover new images nor to search for new ways of representing them. As his health and eyesight deteriorated, the technique he used changed. Painting on a larger scale and often with pastels rather than oils, the pictures of the nineties are distillations of the earlier works. The language is now abbreviated: the essence of the colour, light and movement, the dancers' fatigue and the exhilaration of performance is conveyed through colour and mark, rather than complex compositions made up of detailed figures. It is the atmosphere of the

THE LITTLE DANCER OF FOURTEEN YEARS, 1880

ballet, which Degas has captured in his later paintings, made possible by his years of observation and representation; like the achievement of the dancers themselves, years of hard work culminate in a breathtaking performance.

The search for different ways to portray the dance, and his constant technical experimentation led Degas to produce one of the world's most well-known and best loved pieces of sculpture. *The Little Dancer of Fourteen Years* provoked exclamations of outrage and exaltation on its unveiling at the Sixth Impressionist Exhibition in 1881. Using real hair and clothes combined with bronze and wax, the sculpture was both praised and criticized for its lifelike appearance, but whatever the conclusions of the statuette's many critics, none could deny the originality of its creator. As in the ballet paintings Degas presented the life of the dancer so as to demand attention. Through his compositions, quirky observations and stunning application of paint we are engaged, if not forced into the image, and urged to take a closer look at the reality behind the superficial splendour of the ballet.

THE PLATES

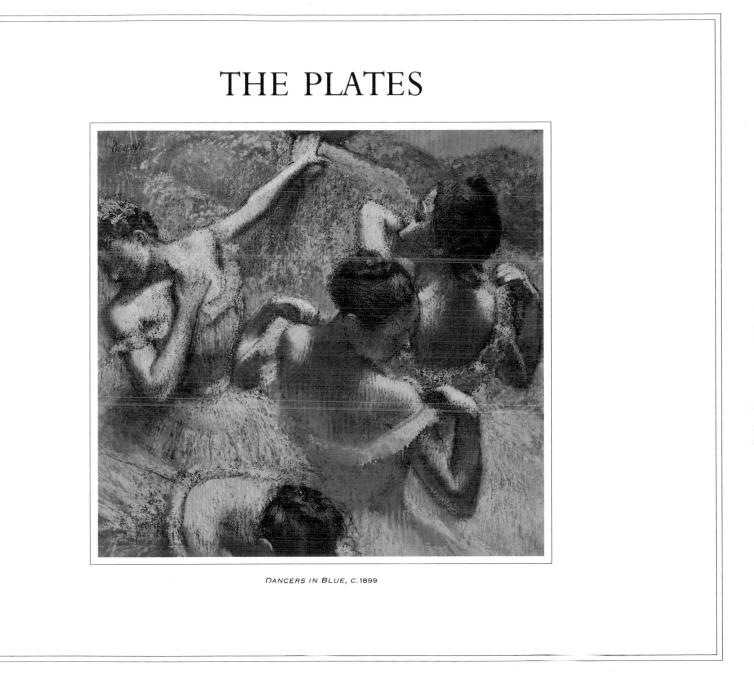

DANCERS IN BLUE, C. 1899

THE ORCHESTRA OF THE OPERA

1868

Musée d'Orsay, Paris

Painted for his friend the bassoonist Désiré Dihau, whose image dominates the foreground, the picture was originally conceived as a more traditional portrait but developed to show the subject in his natural setting – the orchestra pit at the Opéra. The mood of serious concentration on the faces of the musicians is undermined by the humour of the row of headless dancers above, which creates a colourful backdrop to the scene, and by the comical face of the man in the box who is recognizable as the composer Alexis Chabrier. The members of the unconventionally arranged orchestra were also modelled on the artist's friends. Acclaimed as a precursor of modern portraiture for its innovative composition, such as placing the viewer in the front row of the audience, the painting remained in the ownership of the Dihau family until 1935 when it was sold to the Musée Luxembourg, Paris.

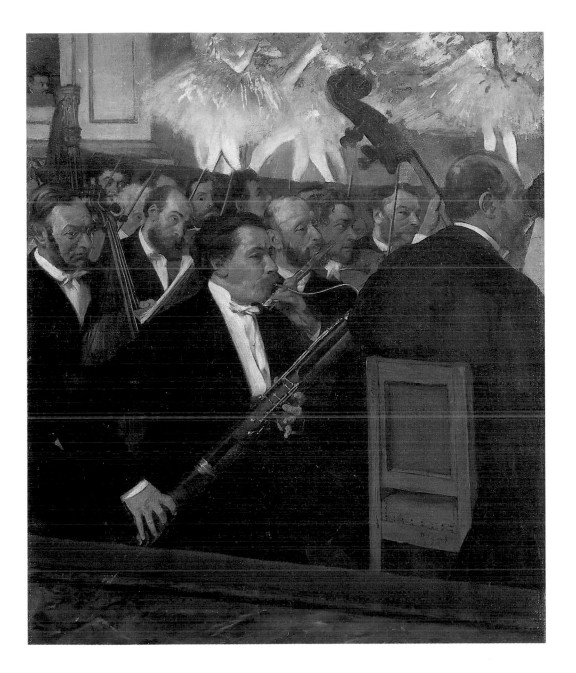

THE DANCING CLASS
———1871———
Metropolitan Museum of Art, New York, Bequest of Mrs H. O. Havemeyer, 1929.
The H. O. Havemeyer Collection.

Introducing elements that were to appear repeatedly in Degas' pictures, such as the seated musician, the watering can to keep the floor damp, and the dancers both in position and at rest, this is the first major composition showing life backstage at the Opéra. The tired dancers who appear almost weightless in their white tulle dresses are contained in an oppressive interior, from which escape is implied through the strongly lit opening in the heavy wooden doors. Amongst the dancers reflected in the numerous mirrors only one is recognizable: alone in the foreground, standing *en pointe arrière*, is the ballerina Josephine Gozelin, whose name appears in the 1870 records of the Opéra.

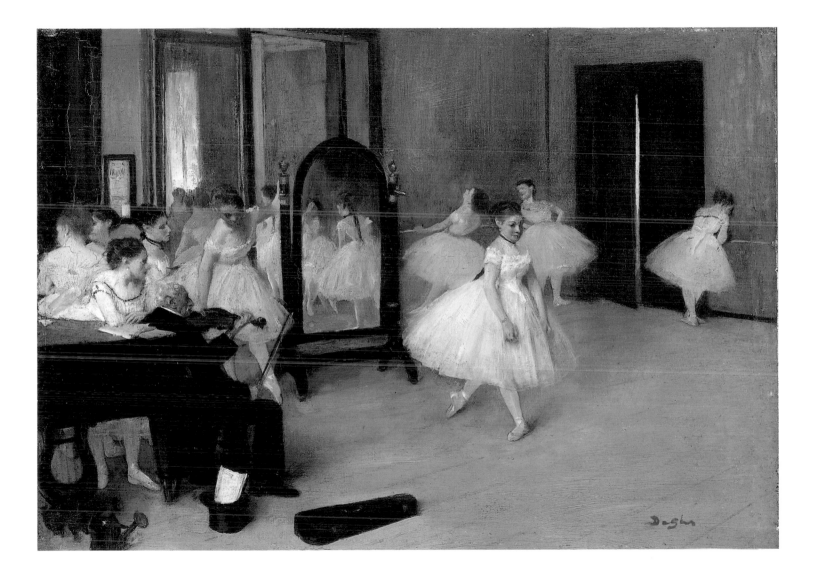

A BALLET DANCER IN POSITION FACING
THREE-QUARTERS FRONT
──────1872──────

Fogg Art Museum, Harvard University, Cambridge, Massachusetts,
Bequest of Meta and Paul J. Sachs

Although Degas took the everyday life of contemporary society as the subject matter for his art, its inspiration came from the great past masters of the Italian Renaissance and the French Academy. He spent many years studying their work, first travelling to Italy in 1858 to make copies. The originality of his paintings is in their combination of a very modern eye with traditional technique. This delicate drawing made in soft pencil with white chalk highlights exemplifies the careful study which he carried out before painting a figure in a composition. The varied marks and the grid of lines describe how the form turns in space while holding a specific ballet position, and reveals the artist's respect for the painter Jean Auguste Dominique Ingres (1780-1867), as recollected by Daniel Halévy: "'Do you want me to tell you a little story about the word *good*?" Degas asked. "It was the only time I talked to Ingres . . . The pictures in his studio are still photographed in my mind. 'Draw lines young man,' he said to me, 'draw lines; whether from memory or after nature. Then you will be a good artist.'"

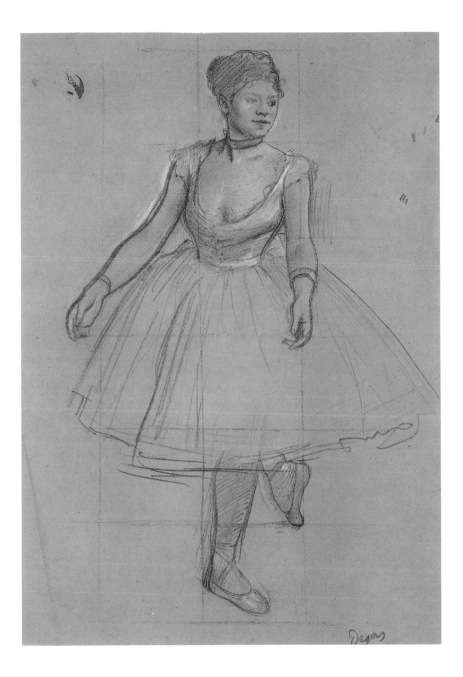

THE FOYER DE LA DANSE
AT THE RUE LE PELETIER OPERA
———1872———
Musée d'Orsay, Paris

'It is impossible to exaggerate the subtlety of exact perception, and the felicitous touch in expressing it, which reveal themselves in his little picture of ballet-girls training beneath the eye of the ballet-master.'

Sidney Colvin in *Pall Mall Gazette*, 28 November 1872

Perhaps prompted by this critical acclaim, *The Foyer de la Danse* was bought by Louis Huth only a few days after the Impressionists' dealer, Paul Durand-Ruel, had sent it for exhibition in London. The comparatively strict composition and limited use of colour seen in this early ballet painting help to convey the discipline and control of the dancers, shown here at a specific moment in the rehearsal procedure. The raised hand of the ballet-master commands the attention of both the ballerinas and viewer; we await only his signal for the music and dance to begin. Although most of the figures are based on quick sketches of anonymous dancers in diluted oil paint (*essence*), the master is recognisable as Louis Mérante, whose own debut on the stage at the Opéra had taken place in 1848.

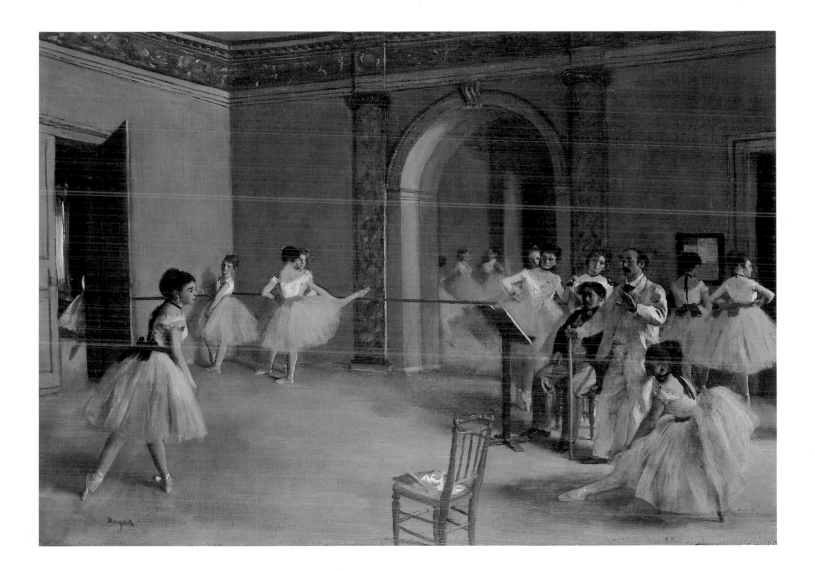

SEATED DANCER SEEN IN PROFILE
———1873———
Cabinet des Dessins, Musée du Louvre, Paris

'Degas used to say that if he had let himself follow his own taste in the matter, he would never have done anything but black and white. "But what can you do," he would ask with a gesture of resignation, "when everybody is clamouring for colour ?"'

Ambrose Vollard in *Degas: An Intimate Portrait*

This familiar pose of a seated dancer scratching her back appears in many of Degas' ballet compositions, such as in the foreground of *Rehearsal of a Ballet on Stage* (1874). Painted *à l'essence,* using oil paint diluted with turpentine, the fluidity of the lines and the effect of the black and white on the blue background paper achieve a beauty no less descriptive than some of the painter's more detailed works.

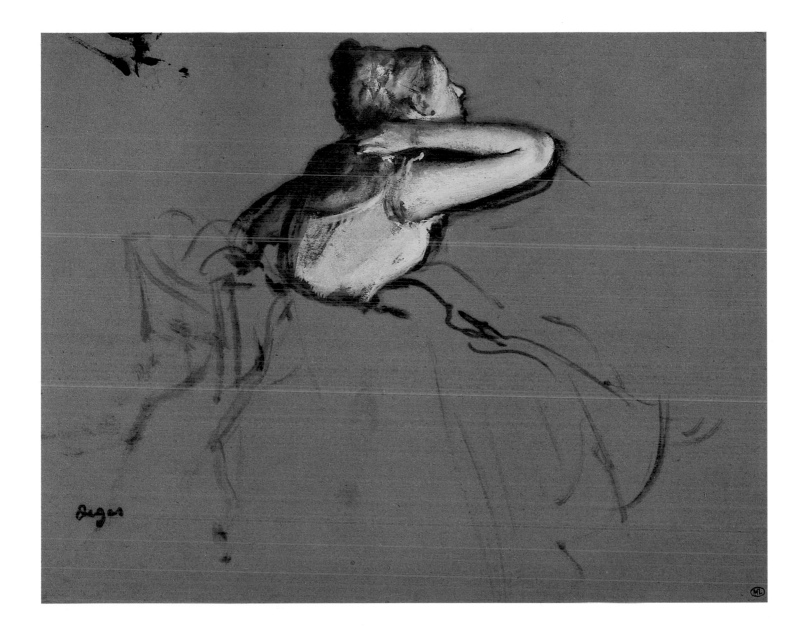

THE DANCING CLASS

————1873-76————

Musée d'Orsay, Paris

Begun, in 1873, this painting was reworked after another version was given to the singer Jean-Baptiste Faure. Unlike the later painting, now in the Metropolitan Museum, the central focus here is undeniably the ballet-master Jules Perrot. Degas altered the composition so that all the dancers, and their mothers watching from the back of the room, are turned towards the teacher, whose walking stick is the central axis of all the activity, highlighting his role as respected mentor. This 'homage' to the master who had once been the star of the Paris ballet with his partner Maria Taglioni was an afterthought made possible by the artist's opportunity to sketch Perrot at work *à l'essence* in 1875. Using stock figures taken from his countless sketches, Degas presents us with a scene of young dancers pausing from the strain of their lesson – adjusting bows, scratching backs and stretching tired muscles.

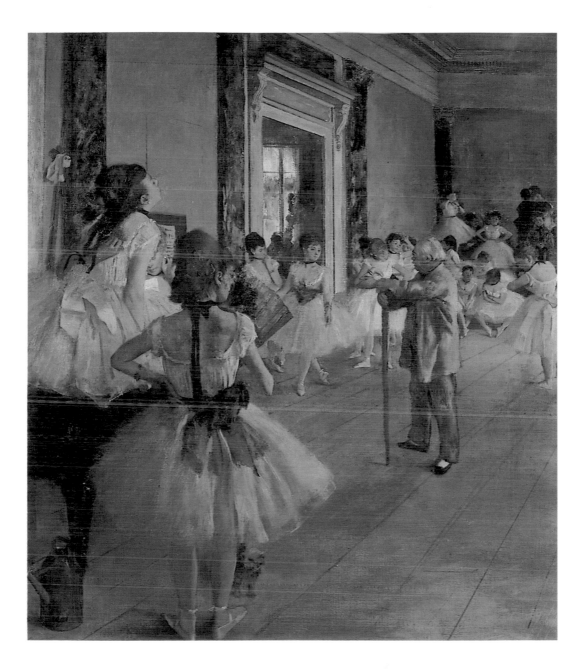

THE REHEARSAL
―――1874―――
Glasgow Museums and Art Gallery

'Yesterday I spent the whole day in the studio of a strange painter called Degas . . . out of all the subjects of modern life he has chosen washer-women and ballet dancers. There was their green-room with, outlined against the light of a window, the curious silhouette of dancers' legs coming down a little staircase, with the bright red of a tartan in the midst of all those puffed-out white clouds, and a ridiculous ballet master serving as a vulgar foil. And there before one, drawn from nature, was the graceful twisting and turning of the gestures of those little monkey girls.'

Diary of Edmond de Goncourt, Friday 13 February 1874

The success of this painting which so impressed its contemporary chronicler lies in its complex balance of opposing elements – the strong sense of the depth of the room contrasts with the emphasis on the picture surface, as does the movement of the group of dancers on the left with the inactivity of those resting on the right. Influenced by the Japanese prints that were becoming widely available in Paris at this time, Degas has used a strong vertical line in the spiral staircase which provides an axis for the painting, as a dancer revolves around an axis in a pirouette. After his death a small model of the staircase was found in his studio, highlighting the artifice of the ballet paintings of the 1870s. The dramatic diagonal sweep of the floorboards and the direction in which the dancers move lead our eye to the ballet master, Jules Perrot, whose figure is taken directly from an early daguerreotype. The mother fussing over her daughter's tutu is also recognizable as the artist's housekeeper Sabine Neyt.

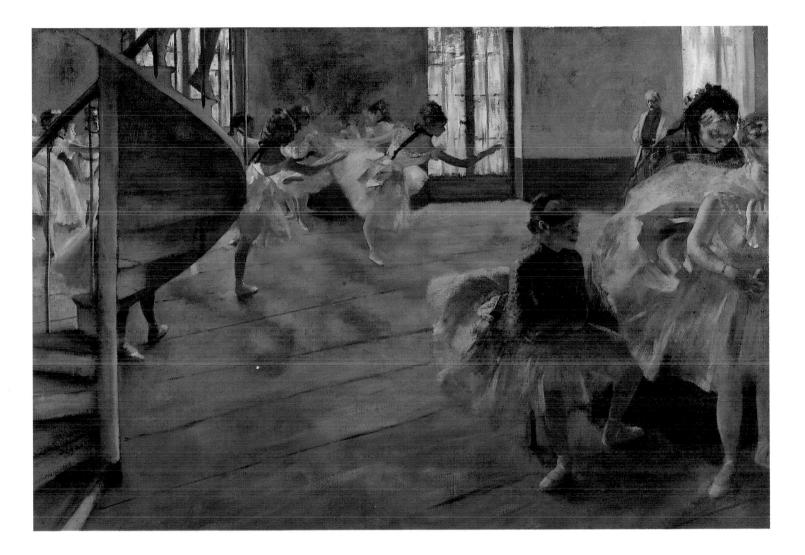

REHEARSAL OF A BALLET ON THE STAGE
———— 1874 ————
Musée d'Orsay, Paris

'I remember a drawing which must have been a dance rehearsal under the glare of the footlights, and I assure you that it is extremely beautiful; the muslin dresses are so diaphanous and the movements so true that you have to see it to understand, to describe it is impossible.' Giuseppe de Nittis, 1874

Writing to his son after seeing this version of the *Rehearsal of a Ballet on the Stage* at the First Impressionist Exhibition, de Nittis found it difficult to express the unusual beauty of the image which is painted in monochrome, using subtle modulations of black and white to transform an everyday scene of work at the Opéra into a magical world of light and movement. It has been suggested that this experiment into a different way of representing the ballet was influenced by the development of photography, in which it is known that Degas was greatly interested both as an aid for his art and as an amateur pastime.

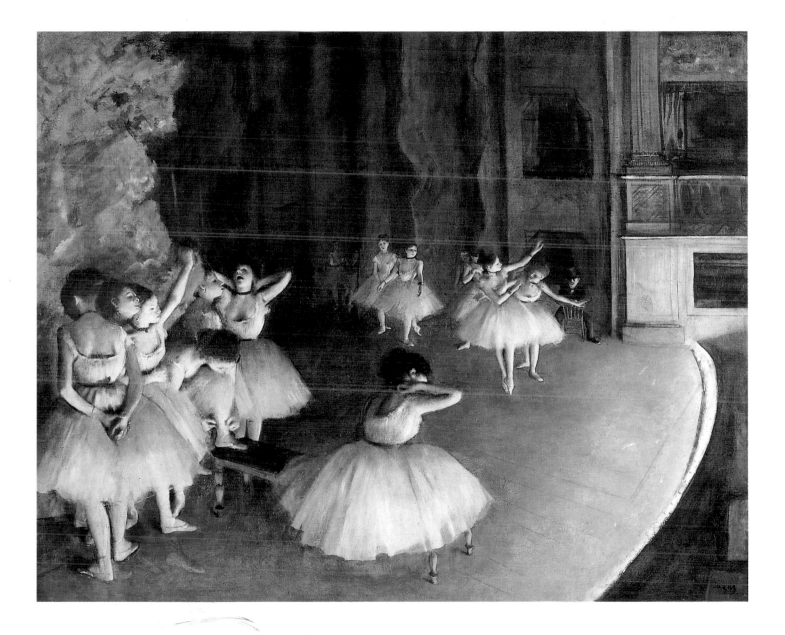

THE REHEARSAL
——— 1875 ———
Metropolitan Museum of Art, New York, Bequest of Mrs H. O. Havemeyer, 1929.
The H. O. Havemeyer Collection

'The man of fashion at the Opera, with his box or his stall, his favourite dancer, his glasses and his right of entry backstage, has a horror of anything which remains on the bills for a long time, of anything artistic, which must be listened to, respected or requires an effort to be understood.'

Charles Yriarte

This scornful contemporary commentary on the bourgeois gentlemen who frequented the ballet – for the company of the young dancers rather than the cultural experience – is reflected in Degas' painting. Unlike the earlier monochrome version, local colours and a more detailed setting have been used to convey the rehearsal scene, overlooked by the two men on the far right. Casually seated on the stage, they watch the dancers directed by the active ballet master in their midst. The painting's purchase by the banker Ernest May disappointed Paul Gauguin, who had admired it in Degas' studio and incorporated some of the figures in a woodcarving of his own.

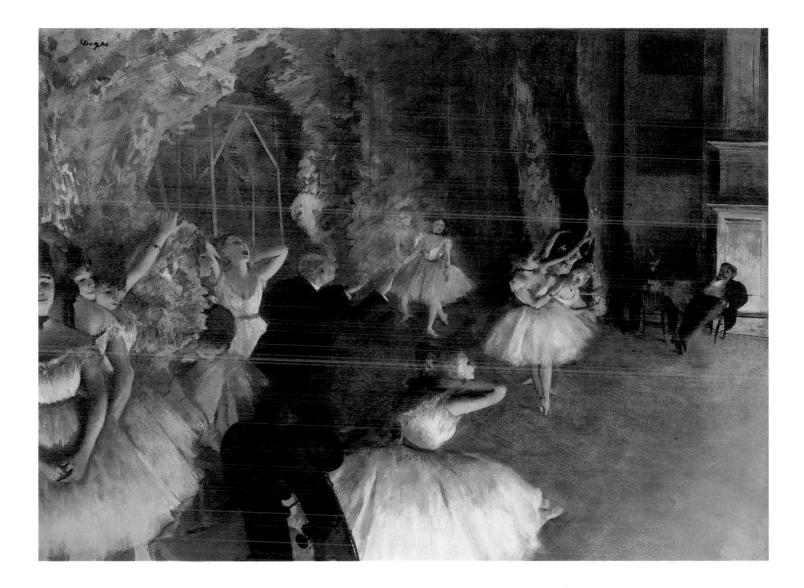

BALLET REHEARSAL

———1876———

Nelson-Atkins Museum of Art, Kansas City, Missouri, Acquired through the Kenneth A.
and Helen F. Spencer Foundation Acquisition Fund

'My dear Hecht, Have you the power to get the Opéra to give me a pass for the day of the dance examination, which, so I have been told, is to be on Thursday? I have done so many of these dance examinations without having seen them that I am a little ashamed of it.'

Degas, undated letter to Albert Hecht

Writing to his friend and collector the banker Albert Hecht, Degas expressed the desire to paint a ballet scene from life, rather than constructing it from a series of individual figure sketches and notes. Although the figure of the ballet master Jules Perrot in his familiar red shirt is a mirror-image of his appearance in *The Dancing Class* of 1873-76, there is a more spontaneous feel to this picture. Rather than the architectural setting of the earlier stage scenes, here the space is more intimate, and the composition less rigorous. This departure from his usual style was also affected by the medium, as Degas has used gouache and pastel to rework his first monotype print, which he had made with his friend the Comte Lepic.

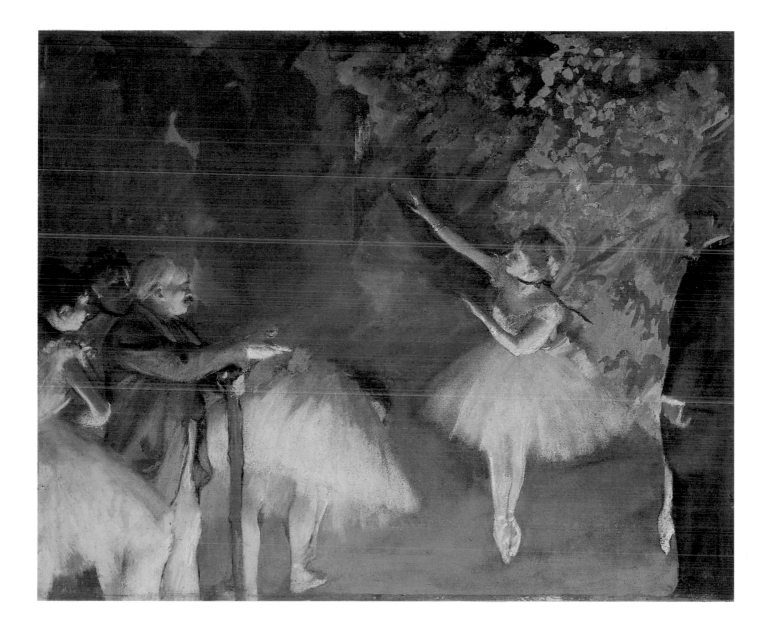

L'ETOILE: ON THE STAGE

——————1876-77——————

Musée d'Orsay, Paris

'There is no need to go to the Opéra after having seen these pastels.'

Georges Rivière at the Third Impressionist Exhibition, 1877

Greatly admired when exhibited as part of a series of pastel drawings over monotype prints, this image was bought by the artist Gustave Caillebotte, whose paintings also represented modern life in Paris. Here Degas emphasizes the contrast between the life of a ballet dancer both on and off stage. The picture is divided in two: in the lower section, the dancer is alone on the vast space of the stage where she appears weightless, a mass of white gauze and light. Because of our privileged position in the Emperor's box, we can also see the real world of the wings – the artifice of the scenery, the dancers awaiting their entrances and most ironically, the presence of a black-suited gentleman. As the shadow masks the identity of the dancer, the stage-set hides the face of her benefactor, who could represent any one of the important, wealthy men who frequented the backstage world of the Opéra.

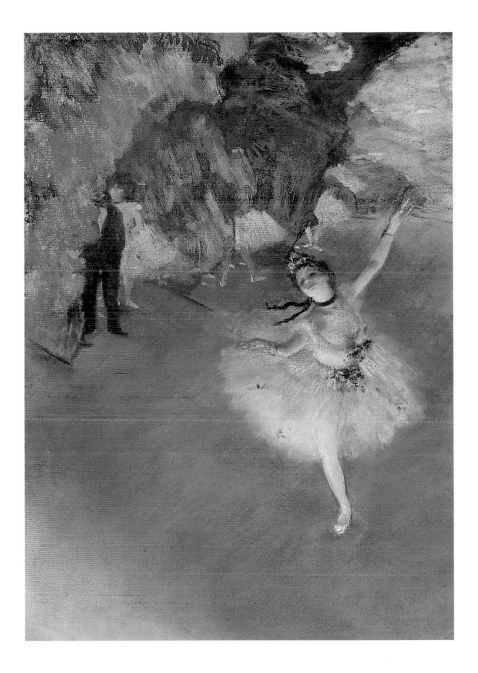

DANCERS PRACTICING AT THE BAR

——— 1876-77 ———

Metropolitan Museum of Art, New York, Bequest of Mrs H. O. Havemeyer, 1929.
The H. O. Havemeyer Collection

For Degas, who worked intensively to perfect his craft throughout his career, the ballet with its requirement for constant practice and dedication was a fascinating subject. As the dancers repeated the set classical movements, he sketched and drew them in the same positions time and time again in order to capture the essence of their art. This painting developed from an accidental placing of two sketches of a dancer seen from different views which is now in the British Museum, and captures the atmosphere of a sunlit rehearsal room using a limited range of colours. While the dancer on the right is preoccupied with her exercise, the distracted gaze of her companion contradicts the painful position she is practicing. The rhythm of their poses is mimicked by the watering can used to keep the dust off the floor, a device which Degas wanted to paint out, but apparently delighted the painting's owner, his great friend, Henri Rouart.

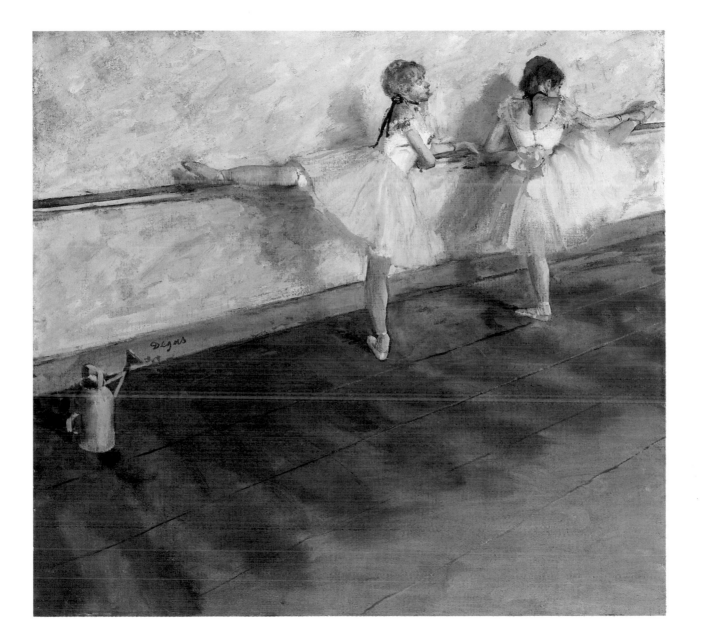

DANCER WITH A BOUQUET SEEN FROM A LOGE
———1877-79———
Museum of Art, Rhode Island School of Design, Gift of Mrs Murray S. Danforth

Her face dramatically transformed into a mask by the glare of the footlights, the principal ballerina receiving applause is unrecognizable as a particular celebrity. Instead the artist is concerned with portraying the relationship between two classes of women as it comes into play within the colourful world of the Opéra. Having extended the image by attaching strips of paper along the base and the right-hand side of the original monotype, Degas reworked the picture using pastels to include the spectator in her *loge*. Through the repetition of the semi-circular shapes of the fan and the dancers' skirts and the strong diagonal of the composition, the fashionably dressed bourgeois spectator is linked to the working class dancer, forcing a comparison between their roles in society. Other Impressionist painters, notably Mary Cassatt and Auguste Renoir, were also dealing with the bourgeois pastime of going to the theatre in order to 'see and be seen'.

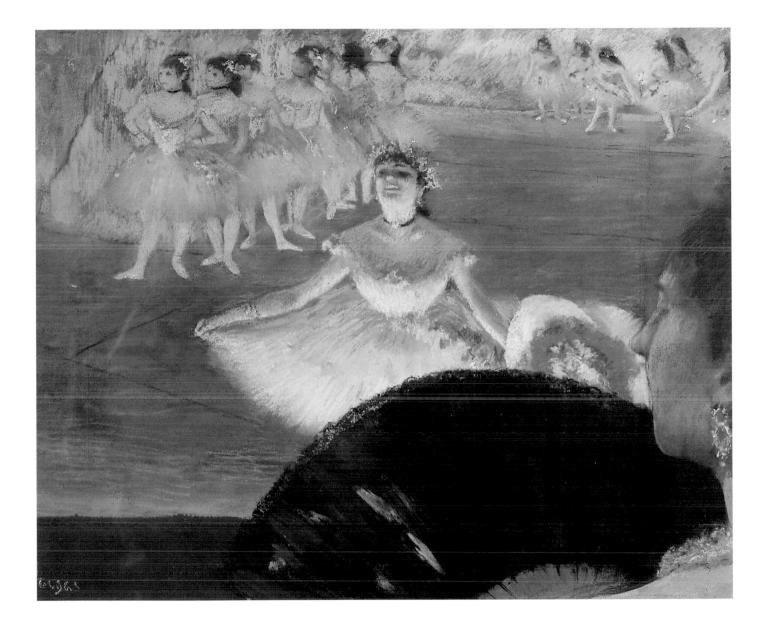

L'ETOILE: DANCER ON POINT
———1878———
Norton Simon Art Foundation

'The dancers are transfixed in poses quite remote from those that the human body can maintain by its own strength . . . while thinking of something else. Consequently, there is a wonderful impression: that in the Universe of Dance, rest has no place; immobility is a thing compelled, constrained, a state of passage and almost of violence while the leaps, the counted steps, the poses on point, the entrechats or the dizzying turns are quite natural ways of being and doing.'

Paul Valéry in *Danse Dessin Degas*

Although this painting represents a ballerina performing on point which was a style of dancing new to the Paris stage in the 1870s, Degas has created a timeless image. By simplifying the coloured shapes of the scenery and obscuring the dancer's face the effect is almost abstract; capturing the movement in a decorative two dimensional pattern. Once again our viewpoint implies our presence backstage, as we see the ballet pose from behind rather than the front view of the audience, for whom it was so carefully choreographed.

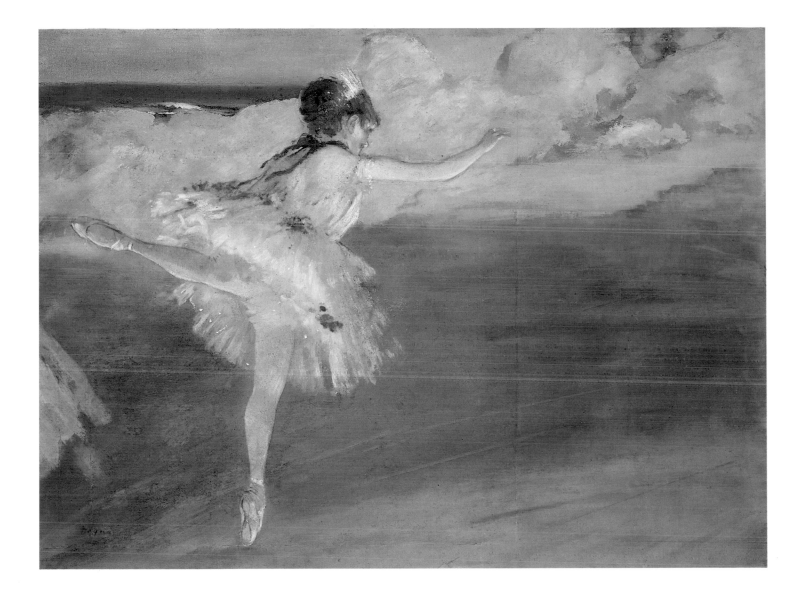

THE BALLET CLASS
───── 1878-79 ─────
Philadelphia Museum of Art, The W. P. Wilstach Collection

Painted for the brother of the artist Mary Cassatt, this image originally featured the large figure of a dancer in the foreground, but by reworking it to incorporate the seated woman, Degas has created a more comical scene. The idealized beauty of the group of dancers by the window is brought down to earth by the graceless form of the woman slumped heavily in her chair. Indifferent to the activity around her, she is engrossed in her newspaper, a device also used by the artist in his 1873 painting, *Portraits in a Cotton Office, New Orleans.* The history of this painting reveals how contemporary art dealers were able to profit from the sales of artists' work, for on 18 June 1881 Paul Durand-Ruel bought the painting from Degas for 5,000 francs and immediately sold it to Alexandre Cassatt for 6,000.

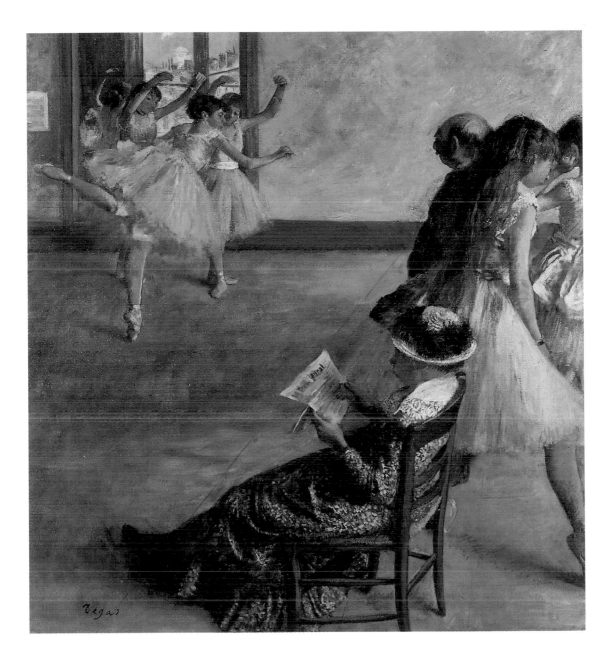

FAN: THE BALLET
———1879———
Metropolitan Museum of Art, New York, Bequest of Mrs H. O. Havemeyer, 1929.
The H. O. Havemeyer Collection

Despite Degas' comfortable upbringing which enabled him to travel and study as a painter, his diaries and letters reveal financial concern after the crash of his family's business in 1874, and occasionally a shortage of money prompted him to combine the marketability of his ballet scenes with the demand for hand-painted fans, which could be sold quickly by dealers. The popularity of decorative fans as fashionable accessories, partly influenced by the large number of Japanese goods imported into Paris, is exemplified in Monet's 1876 painting, *The Japanese Woman,* in which they appear in abundance. This example was bought by Hector Brame, and later sold for 250 francs by Paul Durand-Ruel. The artist has used an unusual technique, defining the dancers and scenery in powdered gold and brass paint against the black silk background.

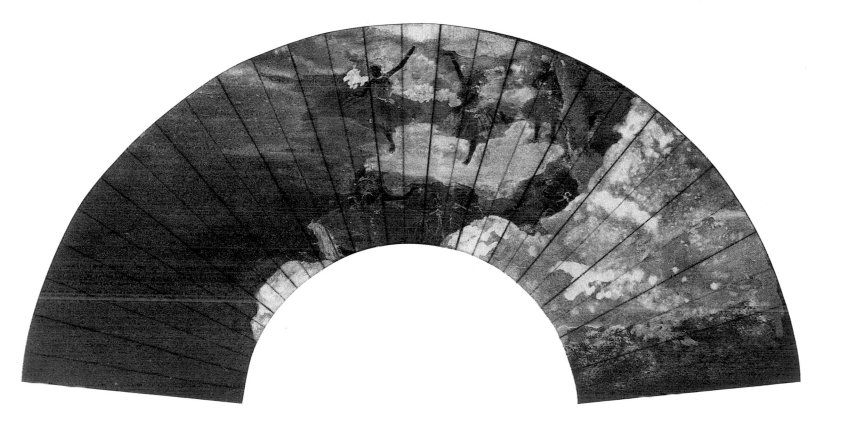

REHEARSAL

———1879———

In this painting, where once again Degas presents us with a scene of preparation for the ballet, there is nothing distancing us from the dancers. Rather than watching from a box, in the wings or just beyond the door of a room, we are placed amongst the dancers in a position where we can command both their puppet-like movements and the violinist's music. The sweep of the floorboards and the unattached dancer's leg on the far right give a sense that there are many more dancers in the room, all practicing this movement with similar mask-like expressions. Exhibited in the Fourth Impressionist Exhibition, this painting shows that although the ballet was the source for the great majority of his work, Degas was consistently searching for new ways of representing his acute observations of its imagery.

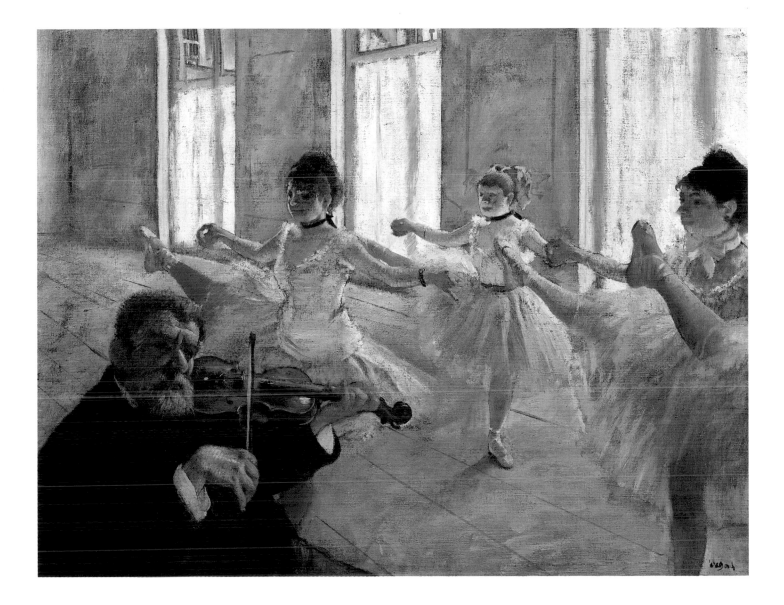

THE ENTRANCE OF THE MASKED DANCERS

————1879————

Sterling and Francine Clark Art Institute, Williamstown, Massachusetts

The demise of the ballet as an elite cultural form and its cross-over into more popular entertainment by the 1870s is documented in this picture. In the background the almost ghost-like figures of the *corps de ballet* wear costumes as if attending a masked ball, a form of entertainment popularized by Louis Napoléon and his wife Eugénie, who enjoyed the anonymity offered by these events. By placing the figures of the two main dancers next to the back of a piece of scenery which is parallel to the picture surface and leaving the middle-ground empty, the artist suggests that we are also standing in the wings. Likewise, on the other side of the stage, the shadowy form of a suited man peeks out from behind the set. Degas has used the pastel in a remarkable way, leaving areas of grey paper exposed and conveying the strong stage lighting with slanted marks of yellow and white.

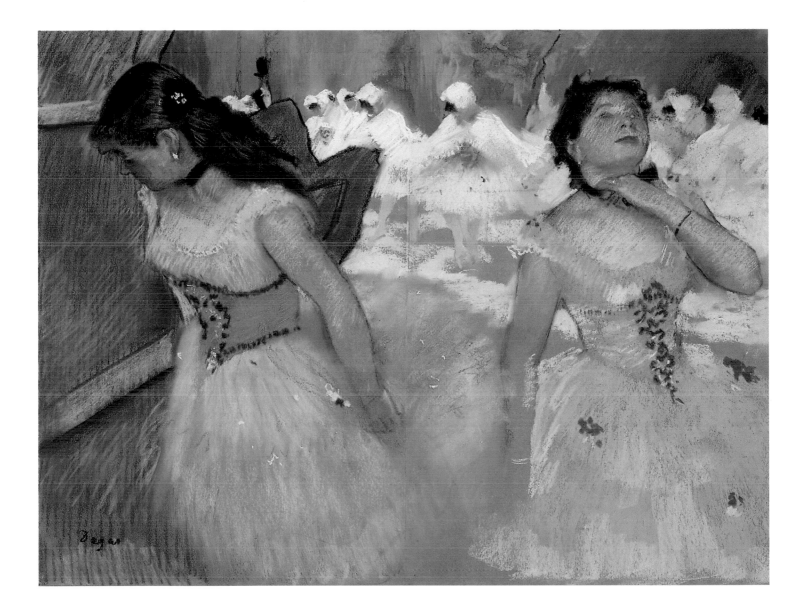

DANCER IN HER DRESSING ROOM
————1880————
Private collection

'Despite the measures that were destined to thin out the crowds of visitors backstage at the Opéra, one only succeeded, curious thing! There is no room for professional curiosity. But, if only you are a financier, an investor wearing yellow gloves, a stockbroker, a rich foreigner, a diplomat, an embassy attaché, a man of the world in high repute; if only you have influence in powerful places; if only you are something like the uncle of a dancer or her *protector,* then the portals become open to you.'

<div align="right">Eugène Chapus in Le Sport à Paris, 1854</div>

Written before Degas began to paint the ballet, this commentary illustrates how the relationship of the bourgeois gentleman to the dancers at the Opéra was accepted within the double standards of Parisian society: while a man could commit adultery almost openly, his wife had no legal rights to divorce him. Here the intimacy between the suited man and the dancer is implied by his presence in her dressing room, whereas we are kept firmly outside by the placing of the armchair.

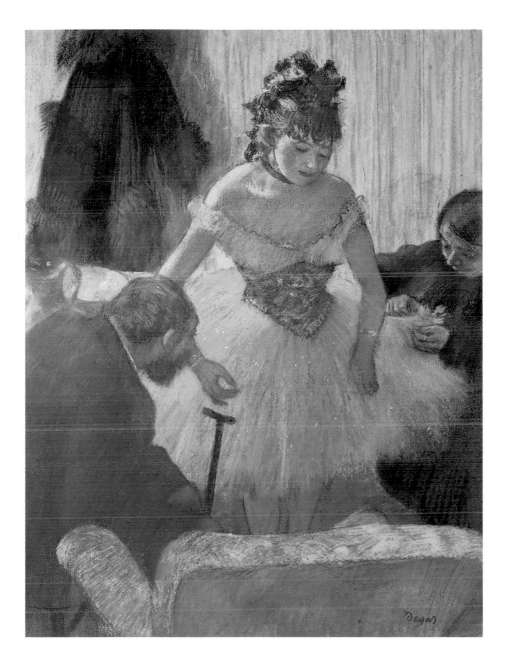

THE DANCING LESSON
——1880——
Sterling and Francine Clark Art Institute, Williamstown, Massachusetts

At work in an unspecified rehearsal room, the dancers appear so fatigued that they are caught up in their own worlds, a feature noted by the contemporary critic J.-K. Huysmans: 'What truth! What life! How all these figures stand free in the atmosphere, how the light bathes every detail of the scene, how the expression of these countenances, the boredom of a laborious mechanical labour, the watchful gaze of the mother whose hopes are raised as her daughter's body drudges away; the indifference of the others to fatigues they know only too well, are emphasized, are recorded with an analytical perspicacity which is at once cruel and subtle!' Degas painted a series of these large compositions, each showing a group of dancers working beyond a walled foreground, and it is believed that with their more generalized portrayal they were intended as possible panels for the decoration of an interior. Painted as a commission for J. Drake de Castle, a government deputy, this picture remained in his collection until 1903 when it was sold for 30,000 francs, showing how even in Degas' lifetime his ballet paintings were appreciating in value.

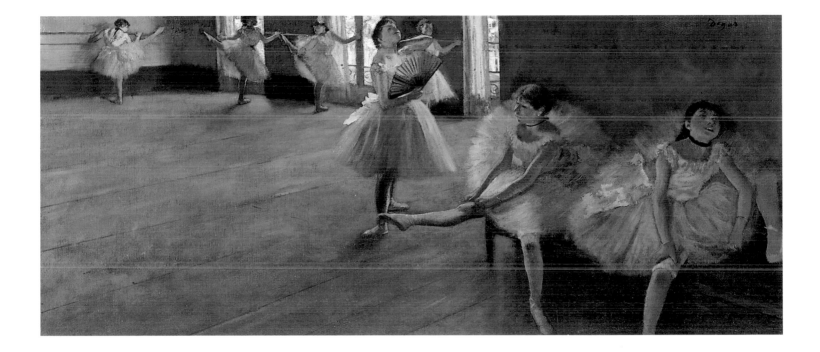

DANCERS RESTING
──────1880-82──────
Julia Cheney Edwards Collection, Courtesy Museum of Fine Arts, Boston

'His models are . . . very particular products of contemporary civilization, of its luxury, of its power, of its poverty and above all of its physiological collapse. No longer the dancer, Muse or Grace of the classical artist, of Mantegna for example, of robust, healthy complete contours who dances slowly as she eats, as she drinks, as she sings, for the pleasure of it, letting her limbs assume, quite freely, postures suggested to her by her natural grace and her need for movement. His is the dancer by will, by ambition, by penury – and by her need for repose. Above all, his is the dancer by training.'
<div align="right">Robert de la Sizeranne in La Revue des Deux Mondes, 1 November 1917</div>

No longer portraying the spectacle of the ballet in complex compositions containing many figures, Degas has focused in on the experiences of the dancers themselves. Here the two figures fill the picture and there are no details to distract us from their mood; instead the image is built up with looser marks and areas of smudged pastel. The bench extends out of the front of the picture into our space, making us identify with the dancers' fatigue. Girls from working class families would come to the Opéra classes at the age of seven, and only after four years of rigorous training and examinations would they begin to receive a salary, which could often be as little as 300 francs a year.

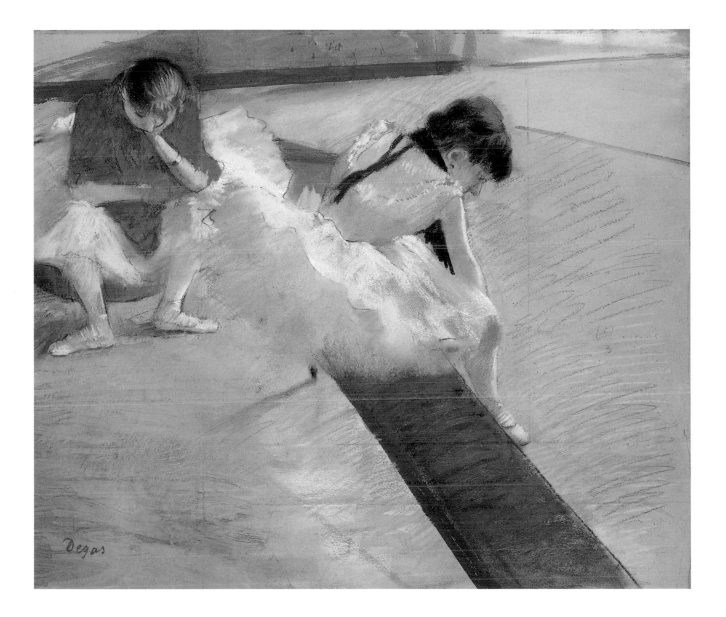

WAITING: DANCER AND WOMAN WITH UMBRELLA ON A BENCH
————1882————

Owned jointly by the J. Paul Getty Museum and the Norton Simon Art Foundation

Degas' simple composition, with the rounded white shapes of the dancer contrasted with the angular black form of her mother, conveys the hours of inactivity and boredom which punctuated the active life of the ballet. While her daughter massages her ankle the woman absent-mindedly scratches the floor with her umbrella, the two figures are so weighed down by their fatigue that they appear to slide out of the picture. The constant supporting presence of the ballerinas' mothers was documented by Ludovic Halévy: 'All around, restless, bewildered, breathless, and purple faced, are mothers, mothers and yet more mothers . . . What serious and delicate matters there are to be considered: that the ribbons of their ballet-shoes are securely tied, that their tights have no creases and are firmly fixed about their hips, that their seams are straight, the bows properly tied and the tarlatan skirts puffed out prettily.'

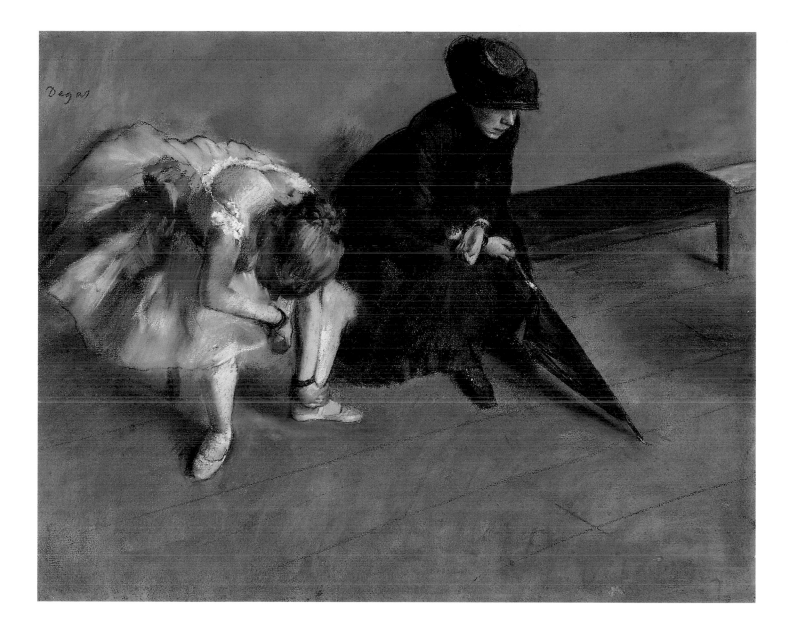

FRIEZE OF DANCERS

———— 1883 ————

The Cleveland Museum of Art, Gift of the Hanna Fund

When asked by Mrs H. O. Havemeyer, a collector of his work, why he continued to paint the subject of the ballet, Degas replied, "Because Madame, it is all that is left us of the combined movement of the Greeks." With its muted colours and row of figures this painting makes reference to the carved marble friezes of antiquity. In the movements of the dancers, even as they lean to adjust a shoe, Degas saw a classical beauty; to him these independent young women were modern day goddesses worthy of their place in art. In the late 1870s and early 1880s, Degas drew and painted a dancer in this pose many times having instructed himself in a notebook of 1876 to 'Make a series of arm or leg movements in the dance which would not move, oneself turning around them – finally study from every perspective a figure or object, no matter what.'

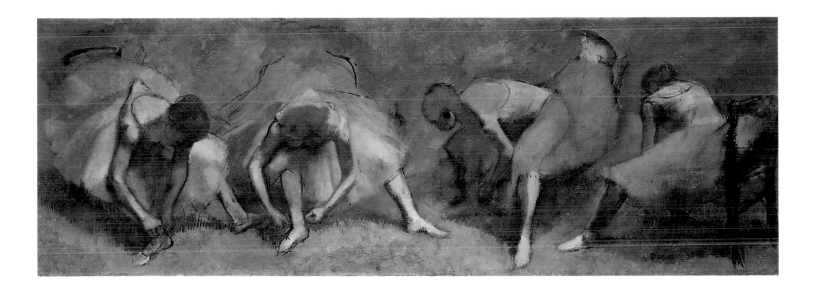

DANCERS WITH A FAN IN A BOX

——————1884——————

Glasgow Museums and Art Gallery

'Ah! Where are the times when I thought myself strong. When I was full of logic, full of plans. I am sliding rapidly down the slope and rolling I know not where, wrapped in many bad pastels, as if they were packing paper.'

<div align="right">Degas, letter to Paul Bartholomé, 16 August 1884</div>

With a new intensity of colour, achieved by leaving his pastels in the sun before use, Degas shows us two dancers on the other side of the stage, perhaps relaxing in the box of a benefactor. Using a rich build up of linear marks Degas has conveyed the colour, light and atmosphere rather than constructing three-dimensional space. It is as if the pattern on the dancer's fan extends over the whole picture to create a decorative picture surface, without losing the sense of distance between the main figures and the dancer receiving applause beyond.

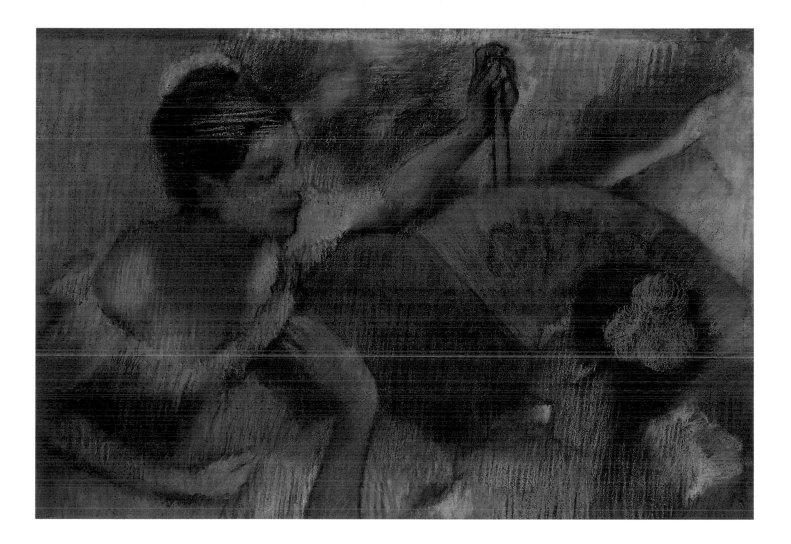

BEFORE THE PERFORMANCE
—— 1896 ——
National Gallery of Scotland

'I have not done badly as regards work, without much progress. Everything is long for a blind man, who wants to pretend that he can see.'

'It's too much, really – so many essential things are going wrong at once. My eyes above all (health is my most precious possession) are far from right. Remember one day you said about someone that he could not *connect* anymore – a term used in medicine to describe failing brains. I remember the word, my eyes no longer *connect,* or it's so difficult for them to do so that I'm often tempted to give up and sleep forever.'

Degas, letters to Alexis Rouart, 1896

Degas had complained about his poor eyesight since the early 1870s when he found it difficult to work in strong sunshine, but by 1896 its rapid deterioration deeply frustrated and distressed him. However, as can be seen in this picture, the artist found new ways of working to accommodate his failing vision. No longer concerned with portraying minute detail and individual textures, he celebrates the light and movement of the ballet with bold colours and fluid brushstrokes. Set against the neutral tones of the backdrop, the rhythm of the bright orange and yellow of the dancers' skirts lead the eye across the painting as if reading a series of musical notes.

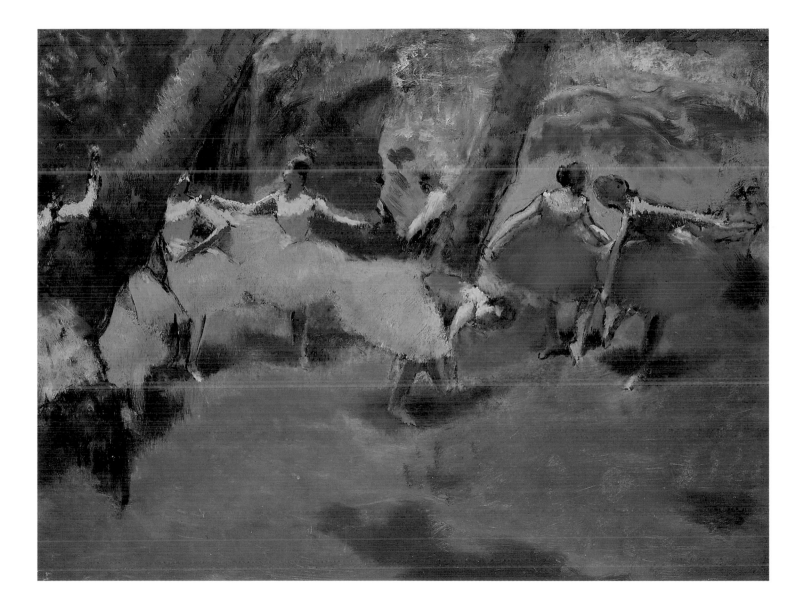

DANCERS ON A BENCH

———1898———

Glasgow Museums and Art Gallery

Degas' well known statement, 'I am a colourist with line', is best under-stood when looking at a painting such as this, for we see how everything is described using line. The composition of four dancers in various poses in a rehearsal room is familiar, but the countless drawings and paintings of the ballet made over thirty years have been distilled, so that with a single black line Degas conveys the contour of an arm or the many layers of a tulle skirt. In the late 1890's Degas had become increasingly absorbed by photography and many humorous accounts exist of his determination in arranging group portraits of his friends. His eyesight steadily diminishing, the effects achieved by collodian printing on glass plates provided new inspiration, as here he translates the multiple views of a dancer picked out by the fall of light using his cross-hatched pastel technique.

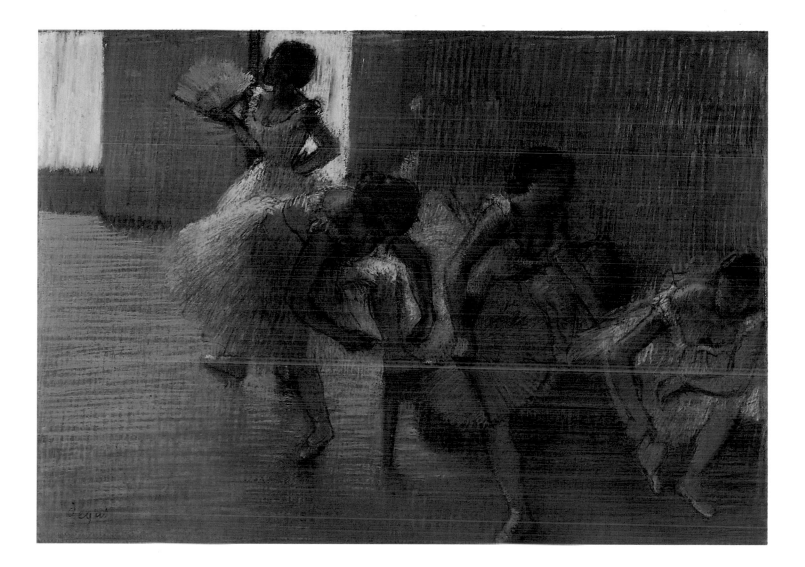

Published in the United States of America in 1992
by UNIVERSE
300 Park Avenue South, New York, NY 10010

ISBN 0-87663-634-2

92 93 94 95 96/10 9 8 7 6 5 4 3 2 1

Text © Georgia Sion 1992

Produced, edited and designed by Russell Ash & Bernard Higton
Picture research by Mary Jane Gibson
Printed and bound in Singapore by Tien Wah

Library of Congress Cataloging-in-Publication Data

Degas, Edgar, 1834-1917.
 Degas' ballet dancers.
 p. cm.
 ISBN 0-87663-634-2
 1. Degas, Edgar, 1834-1917. 2. Ballet dancers in art.
I. Title.
N6853.D33A4 1992
759.4-dc20 92-13167
 CIP

Picture credits
All plates are from the sources shown in the captions unless
otherwise indicated below.

Front cover (*The Rehearsal*, 1875) Metropolitan Museum of Art,
New York, H. O Havemeyer Bequest, 1929; page 1 detail from
plate page 41; 2 Private collection; 4 Louvre, Cabinet des
Dessins; 5 (photo of Degas), 6 (sketchbook), 8 (Degas' pho-
tographs) Bibliothèque Nationale; 6 (*Ludovic Halévy and Mme

Cardinal) Staatsgalerie Stuttgart; 7 (*The Tub*), 10 Musée d'Orsay,
Paris; 7 (*The Ballet Master, Jules Perrot*) Philadelphia Museum of
Art, The Henry P. McIlhenny Collection in memory of Frances
P. McIlhenny; 9 Victoria & Albert Museum; 11 and back cover
Pushkin Museum, Moscow.

Photo sources: Artothek; Edimedia; Bridgeman Art Library;
Christie's London; Colorphoto Hans Hinz; Photo RMN Paris;
Visual Arts Library.